MW01073802

HARLEM

HARLEM

GAYATRI CHAKRAVORTY SPIVAK

WITH PHOTOGRAPHS BY ALICE ATTIE

LONDON NEW YORK CALCUTTA

Seagull Books, 2012

Text © Gayatri Chakravorty Spivak, 2012
Photographs by Alice Attie © Alice Attie, 2000
This Compilation © Seagull Books, 2012

ISBN-13 978 0 8574 2 084 8

British Library Cataloguing-in-Publication Data
A catalogue record for this book is available from the British Library

Typeset is Chaparral Pro and ITC Officina Sans Book/Bold
by Seagull Books, Calcutta, India
Printed and bound by Hyam Enterprises, Calcutta, India

CONTENTS

HARLEM

Here is the site of a major double bind. How deny 'development' to the disenfranchised? This is where the Du Bois/Gramsci lesson—aesthetic education for the subaltern, so that hegemony is grasped responsibly—becomes crucial. Mere nostalgia, which would celebrate those 'tribals in aspic', for example, indulged in by Mahasweta Devi and Gopiballabh Singh Deo, is useless here. If anything, this piece showcases the precariousness of the way from 'freedom from' to 'freedom to', as well as paying attention to the fact that capitalist 'development', must persistently subalternize. Today, when US racism has suborned conservative Christian African-America for a future subalternization that will help this, it is even more important to remember this. I will be forgiven if I no longer have the conviction that this memory will survive.

Alice Attie showed me her photographs of Harlem.[1]
The images haunted me and interpellated me as a New
Yorker. A month before this, 21 photographs of the base
of the eleventh-century Brihadeeswara Temple in Than-
javur, taken in 1858 by a captain in the British Army, had
beckoned. What was that interpellation? I have not come
to grips with that one yet but it launched me for a while
on the question of photographs and evidence of identity.
Harlem moved on to a big map.

In Dublin, I could juxtapose the Harlem images with
allochthonic Europe. What is it to be a Dubliner? Roman-
ian, Somali, Algerian, Bosnian Dubliner? What is it to be
a high-tech Asian Dubliner, recipient of the 40 per cent
of official work permits? Diversity is class differentiated.
How does the anti-immigration platform 'Return Ireland
to the Irish' relate to the ferocious dominant-sector cul-
turalism that is reconstituting Harlem today? A class
argument subsumed under this culturalism, pronouncing
received antiglobalization or pro-working-class pieties,
will nicely displace the question. This became part of my
argument.

..

1 See Alice Attie, *Harlem on the Verge* (New York: Quantuck
Lane Press, 2003).

In Brazil's Bahia, I learned what the Movimento Negro owed to African America in the US. In Hong Kong in 2001, I saw that the word 'identity' attached to the name of a place such as Hong Kong indicated yet another species of collectivity: postcolonial. Between Great Britain and China, the Hong Kong cultural worker staged a loss of identity. If the quick sketch of Dublin foregrounds the class division in diversity, the staging of Hong Kong makes visible the fault lines within what is called 'decolonization'.[2]

...

2 Wong Kar Wai's film *Chungking Express* (1994) stages this by robbing well-established cinematic idiom—French New Wave, American noir and gangster movies—of all the expected semantic charge. On the cultural studies front, Ackbar Abbas' work comments most extensively on this cultural denuding: 'Hyphenation: The Spatial Dimensions of Hong Kong Culture' in Michael P. Steinberg (ed.), *Walter Benjamin and the Demands of History* (Ithaca, NY: Cornell University Press, 1996), pp. 214–31; 'Hong Kong: Other Histories, Other Politics', *Public Culture* 9 (1997): 293–313. Meaghan Morris, a relative newcomer to Hong Kong, bypasses this history as she plunges into global Hong Kong in 'On English as a Chinese Language: Implementing Globalization' in Brett De Bary (ed.), *Universities in Translation: The Mental Labour of Globalization* (Hong Kong: Hong Kong University Press, 2010), pp. 177–96.

In 1996, Taiwanese artist Tsong Pu thought of his work *Map* (figures 1a–1b) as marking a contradiction between 'lucid Chinese names and maps, and [the] ambiguous concept[s] of China and [its] names', questioning precise identities, as set down by names and maps.[3] He was perhaps inserting Hong Kong, via repatriation, into the confusion of the question of two Chinas, of one country, two systems. Nineteen ninety-seven was the official repatriation, the promise of a release. The artist could be conceptualizing this as a frozen series of bilateralities—no more than two chairs, a small rectangular table, rather emphatically not round. Hong Kong and the PRC, Hong Kong and Britain, UK and PRC: bilateralities. The rough concrete block, commemorating the promised release, in fact imprisons the two unequal partners. (Only the back of one chair has something like headphones attached.) Rough concrete blocks weigh down bodies that must drown without trace. The chairs are empty, no bodies warm them, they cannot be used. The figure '1997' is engraved on one side of the block and embossed on the other. To what concept might this refer?

..

3 Tsong Pu, *Journey to the East 1997* (Hong Kong: Hong Kong University of Science and Technology Center for the Arts, 1997), p. 92.

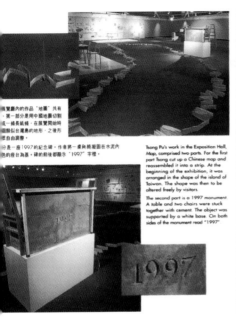

Figure 1a (*top*) *Map*, Tsong Pu (1996). Exhibition catalogue, Hong Kong University of Science and Technology.

Figure 1b (*bottom*) Detail from *Map*.

To the strength of the piercing of that date into the history of the city-state as it displaces itself? To the fact of piercing out but not through? The power of conceptual art is that, as the visual pushes towards the verbal, questions like these cannot be definitively answered.

Culture as the site of explanations is always shifting. The cultural worker's conceptualization of identity

becomes part of the historical record that restrains the speed of that shift or drift. It feeds the souls of those in charge of cultural explanations, who visit museums and exhibitions. British critic Raymond Williams would call this restraining effect the 'residual' pulling back the cultural process.

I spent five months in Hong Kong. I never saw anyone looking at *Map*. Culture had run away elsewhere.

The photograph of Ethernet delegates is a dynamic mark of identity, sharing in the instantaneous timing of virtual reality. The 'Ethernet' band can be put away tomorrow but is always available round the corner. Conceptuality moves on a clear path here—from the slow cultural confines of postcoloniality as repatriation into the quick fix of the culture of global finance. What is the relationship between the innocence and charm of these young people and the occlusion of class interests?

Who sends the collective messages of identity? Who receives them? It is surely clear that Tsong Pu may not have been the real sender of the many messages that his piece can project. And of course I, a female Indian academic teaching English in the US for over two-thirds of my life, may not be its felicitous receiver.

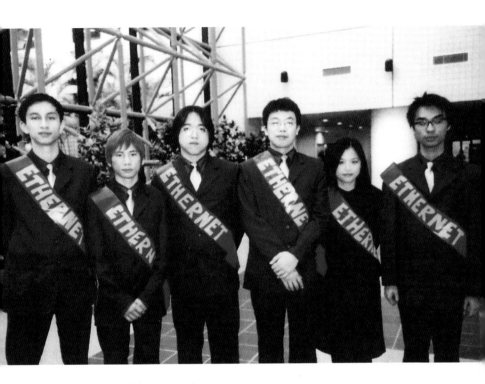

Figure 2 Ethernet employees.

I want to keep the question of the sender and the receiver in mind as I move myself from Port Shelter, China, to Harlem, United States. Who sends, and who receives, when messages assuming collectivities are inscribed? What are identities in megacities like Hong Kong and New York where floating populations rise and fall?

Harlem is a famous place, 'a famous neighborhood rich in culture,' says PBS TV. If the intellectual and the artist stage Hong Kong as emptied of cultural identity, the general dominant in New York is now interested in pronouncing Harlem as metonymic of African America in general. If the texture is so multiple, how may we imagine globality? It is best to sharpen the imagination rather than collect and classify an impossible embarrassment of content.

In 1658, Peter Stuyvesant, the Dutch governor of New Netherland, established the settlement of Nieuw Haarlem, named after Haarlem in the Netherlands. Through the eighteenth century, Harlem was 'an isolated, poor, rural village'.[4] In the nineteenth century, it became a fashionable residential district. Following the panic of 1893, property owners rented to Blacks and by the First World War, much of Harlem was firmly established as a black residential and commercial area, although race and class cross-hatching was considerable.[5] From then until

4 Gilbert Osofsky, *Harlem: The Making of a Ghetto* (Chicago, IL: Ivan R. Dee, 1996[1966]), p. 71. I am grateful to Brent Edwards for sharing some references. Some of the prose is a paraphrase of the *Encyclopedia Britannica* entry on Harlem.

5 For an unsentimental account of this, see Jervis Anderson, *This Was Harlem: 1900-1950* (New York, NY: Noonday, 1981).

the 1990s, Harlem was the scene of fierce deprivation and fierce energy. The chief artery of black Harlem is 125th Street. Columbia University, a major property owner in the area, spreads unevenly up to the edge of 125th and pushes beyond. Since the 1990s, Harlem has been the focus of major economic 'development' and the property ownership graph is changing. Part of the 'development' package seems to be an invocation of a seamless community and culture marking the neighbourhood, on left and right, finally working in the same interest: the American dream. The US thinks of itself as 'global' or 'local' interchangeably. At this point, nothing in the US, including Harlem, is merely counterglobal.

This essay is not part of the voluminous social history of Harlem, now coming forth to code development as freedom in the name of culture. I have not the skill. Robin Kelley's introduction to Attie's *Harlem on the Verge* integrates the photographs into that particular stream.[6] I only raise questions. (Now, revising, I locate the question that was always there: Can an aesthetic education nuance the American Dream? At best, it's a chance.

..

6 Robin Kelley, 'Disappearing Acts: Capturing Harlem in Transition' in Attie, *Harlem on the Verge*, pp. 9–17.

Today, we are in the worst-case scenario for the duration.) That is my connection to Aaron Levy's *Cities without Citizens*.[7] Like Levy, I question archivization, which attempts not only to restrain but also to arrest the speed of the vanishing present, alive and dying. I question the evidentiary power of photography. The question changes, of course. Here, on the Upper West Side of New York, the question becomes: In the face of class-divided racial diversity, who fetishizes culture and community? The only negative gesture that I have ever received from a black person in New York has been from a near-comatose drunken brother in the 96th Street subway station who told me to 'take my green card and go home'. That is not culture turned racism but a recognition of the class division in so-called diversity. At the end of the day, my critical position (though, as he noticed, not my class position or my class interest) is the same as his.

W. E. B. Du Bois describes the African American at the end of the nineteenth century as 'two souls . . . in one dark body, whose dogged strength alone keeps it from

..

7 *Cities without Citizens: Statelessness and Settlements in Early America*, curated by Aaron Levy, Rosenbach Museum and Library, Philadelphia, 8 July–28 September 2003.

being torn asunder'.[8] In the development and gentrified 'integration' of Harlem today, the hyphen between these two souls (African and American, African-American) is being negotiated. Therefore, Alice and I attempt teleopoiesis, a reaching towards the distant other by the patient power of the imagination, a curious kind of identity politics in which one crosses identity as a result of migration or exile.[9] John Keats tries it with the Grecian urn, James Joyce with the Odyssey, with the Wandering Jew. We beg the question of collectivity, on behalf of our discontinuous pasts, her mother in Damascus, I in India, as New Yorkers. If the Ghost Dance accesses something like a 'past' and grafts it to the 'perhaps' of the future anterior, teleopoiesis wishes to touch a past that is historically not 'one's own' (assuming that such a curious

..

8 W. E. B. Du Bois, *The Souls of Black Folk* in *The Oxford W. E. B. Du Bois* (Henry Louis Gates Jr ed.) (New York, NY: Oxford University Press, 2007), VOL. 3, p. 3. *The Oxford W. E. B. Du Bois* is henceforth referred to as ODB.

9 Jacques Derrida speaks of teleopoiesis in *Politics of Friendship* (George Collins trans.) (New York, NY: Verso, 1997). I have connected it to cultural work in 'Deconstruction and Cultural Studies: Arguments for a Deconstructive Cultural Studies' in Nicholas Royle (ed.), *Deconstructions: A User's Giude* (New York: Palgrave, 2000), pp. 14–43.

fiction has anything more than a calculative verifiability, for patricians of various kinds). We must ask, again and again, how many are we? who are they? as Harlem disappears into a present that demands a cultural essence. These are the questions of collectivity, asked as culture runs on. We work in the hope of a resonance with unknown philosophers of the future, friends in advance.

The *Encyclopaedia Britannica* says 'Harlem as a neighbourhood has no fixed boundaries.'[10] Of course the *Encyclopaedia* means this in the narrow sense. For Attie, a photographer with a Euro-US father and a mother from Damascus, and for me, resident alien of Indian origin, these words have come to have a broader meaning. It has prompted us to ask: What is it to be a New Yorker? We are New Yorkers, Alice and I. Our collaboration is somewhat peculiar in that I emphasize our differences rather than our similarities. In the summer of 2000, I said, 'Alice, you're not to mind the things I say about you. One thing is for sure. The photos are brilliant.' She came up to me from behind, gave me a hug and kissed me on my neck. You decide if these words are a record of betrayal.

..

10 *The Encyclopaedia Britannica* (online edition), s. v. 'Harlem'. Available at http://www.britannica.com/EBchecked/topic/-255384/Harlem (last accessed on 23 August 2012).

'For the past thirty years,' Alice wrote in her field notes, 'I have lived on 105th Street and West End Avenue, a fifteen-minute walk from the heart of Harlem in New York City. Only recently, in April of 2000, did I venture into this forbidden territory and experience a community of warmth, generosity, openness, and beauty. The dispelling of some deeply embedded stereotypes has been a small part of the extraordinary experience I have had walking the streets and conversing with the residents of Harlem.'[11]

I have lived in the US for 51 years and in Manhattan for 21. I went to Harlem the first week of my arrival, because my post office is there. Someone in my office warned me that it might be dangerous. In the middle of the day! I have been comfortable in Harlem since that first day, perhaps because Harlem gives me the feel of, although it does not resemble, certain sections of Calcutta. But write about Harlem? Identitarianism scares me. That is, my identity investment in this. It is in the interest of the catharsis of that fear that I have tried this experiment and asked: How do we memorialize the event? I have tried to avoid the banalities of globalized

[11] These words are somewhat modified in the headnote to the acknowledgments in Attie, *Harlem on the Verge*, p. 119.

contemporaneity and asked: As 'culture' runs on, how do we catch its vanishing track, its trace? How does it affect me as a New Yorker? Has the dominant made it impossible to touch the fragility of that edge?

Eine differente Beziehung.[12] This is a Hegelian phrase, which describes the cutting edge of the vanishing present. The present as event is a differencing relationship. I could add a modest rider to that. By choosing the word *Beziehung* rather than *Verhältnis* for relationship, Hegel was unmooring the present from definitive structural truth claims, for he invariably uses the latter word to indicate the structurally correct placement of an item of history or subject. I must repeat my question: How does one figure the edge of the differencing as past, as something we call the present unrolls? For it is important in figuring the preservation of culture as 'heritage' as the future 'develops', usually without an imagination trained in epistemological performance, constructing past and future as objects of knowing.

I have been arguing for some time that on the ethical register, pre-capitalist cultural formations should not be

12 Cited in Jacques Derrida, 'Différance' in *Margins of Philosophy* (Alan Bass trans.) (Chicago, IL: University of Chicago Press, 1982), p. 14.

regarded in an evolutionist way, with capital as the telos. I have suggested that culturally inscribed dominant mindsets that are defective for capitalism should be nurtured for grafting on to our dominant. (I now believe that this has become institutionally impossible.) This is a task for which all preparation can only be remote and indirect. It does, however, operate a baseline critique of the social Darwinism implicit in all our ideas of 'development' in the economic sense and 'hospitality' in the narrow sense. I am a New Yorker. As Harlem is 'developed' into mainstream Manhattan, how do we catch the cultural inscription of delexicalized cultural collectivities?

To lexicalize is to separate a linguistic item from its appropriate grammatical system into the conventions of another grammar. Thus, a new economic and cultural lexicalization, as in the development of Harlem, demands a delexicalization as well. Identitarianism is a denial of the imagination. The imagination is our inbuilt instrument of othering, of thinking things that are not in the here and now, of wanting to become others. I was delighted to see, in a recent issue of the *Sunday New York Times*, devoted to the problem of race, that Erroll McDonald, a Caribbean American editor at Pantheon Books, thinks that 'at the heart of reading is an open engagement with

another, often across centuries and cultural moments.'[13] In the academy, the myth of identity goes something like this: the dominant self has an identity, and the subordinate other has an identity. Mirror images, the self othering the other, indefinitely. I call this, in academic vocabulary, an abyssal specular alterity.[14] To look for the outlines of a subject that is not a mirror image of the dominant, we have to acknowledge, as does McDonald, that any object of investigation—even the basis of a collective identity that we want to appropriate—is other than the investigator. We must investigate and imaginatively constitute our 'own' unclaimed history with the same

..

13 Quoted in Amy Finnerty, 'Outnumbered: Standing Out at Work', *New York Times*, 16 July 2000. Available at http://partners.nytimes.com/library/magazine/home/20000716mag-work-mcdonald.html (last accessed on 3 September 2012). Mr McDonald, you may have 'decided Derridean deconstruction wasn't for me', but this liberating statement, standing alone in an issue full of clichés, shows that you can't take the Yale out of Erroll.

14 If one credited the Lacanian narrative, this would be a kind of group mirror stage, to be superseded by the symbolic (Jacques Lacan, 'The Mirror Stage' in *Ecrits* [Bruce Fink trans.] [New York, NY: W. W. Norton, 2006], pp. 75–81). I can hang in with this kind of generalized psychoanalytic talk only as long as it remains general.

teleopoietic delicacy that we strive for in the case of the apparently distant. The most proximate is the most distant, as you will see if you try to grab it exactly, in words, or, better yet, to make someone else grab it. If we ignore this, we take as demonstrated the grounds of an alternative identity—that which we set out to establish. This may be useful for combative politics but not for the reinvention of our discipline.[15] Yet the combat cannot be forgotten. That is indeed the point of the present volume.

I asked Alice to select photographs that had inscriptions, no live figures. The humanism of human faces, especially in a time of mandatory culturalism, guarantees evidentiary memories, allows us to identify the everyday with the voice of recorded and organized public protest. 'Of a necessity the vast majority of [the Negroes in Harlem] are ordinary, hard-working people, who spend their time in just about the same way that other ordinary, hard-working people do.'[16] These inscriptions, each assuming a collectivity, are a bit exorbitant to both public

..

15 To see how this ruse works for constitutions, see Jacques Derrida, 'Declarations of Independence', *New Political Science* 15 (1986): 7–15; and Jacques Derrida and Mustapha Tlili (eds), *For Nelson Mandela* (New York, NY: Seaver, 1987).

16 James Weldon Johnson, *Black Manhattan* (New York, NY: Da Capo, 1991), p. 161.

protest and the mundane round. The inscriptions are now mostly gone. New buildings have replaced them. Already when they were photographed, there were no senders or receivers for these collectivities—in a sense different from the way this may be true of all messages— although the messages could still be read. This is the eerie moment of delexicalization, congealing into a 'past', even as I speak. Inscriptions are lexicalized into the textuality of the viewer and it is the unexpected that instructs us. Therefore, I asked for shots that inscribe collectivities and mark the moment of change.

We are both parts of the text—'New Yorker' is a collective term. How many are we? We are residents of Morningside Heights. How much of us is Harlem? How is synoikismos possible?[17]

Wake Up, Black Man (figure 4) is on the wall of a landmark warehouse on 123rd Street. Today, with the knowledge that the building is standing skeletal and gutted, after passing through consideration by Columbia

..

17 This is Edward Soja's term for the sort of living together that is the motor of history. See Edward Soja, *Postmetropolis: Critical Studies of Cities and Regions* (Malden, MA: Blackwell, 2000), pp. 12–18.

University, Robert De Niro, and a community group that would have turned it into a cultural centre, it seems more interesting that the message was on a warehouse. My fellow critic is still the brother in the subway station. No amount of pious diversity talk will bridge the constant subalternization that manages the crisis of upward class mobility masquerading as the politics of classlessness. Who is this Black Man and to what would he have awakened? Who wrote on the warehouse wall? Was it a felicitous writing surface? Questions that have now disappeared.

I come from an inscribed city, Calcutta, whose inscriptions are in the mode of disappearance as the state of West Bengal moves into economic restructuring. The inscriptions of Calcutta, in Bengali, are never read by international commentary, Left and Right. As I write, I have a vision of writing a companion piece for my hometown. How will it relate to the early imperial photographs, imprints taken by egg white smoothed on waxed paper, of the temple inscriptions that set me to read photographs? (see figure 3) Questions that must be asked before the Calcutta street inscriptions disappear.

The entire argument of this essay (the fragility of the differantiating moment) is captured in the difference

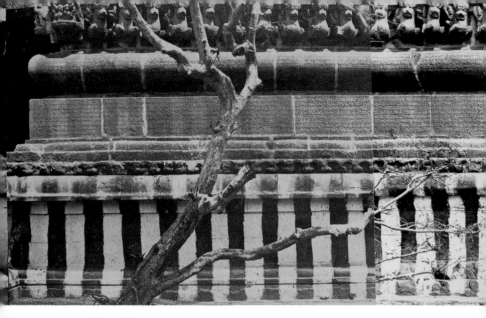

Figure 3

between the photograph above and a contemporary digital representation.[18] In the era of globalization, a simulation

..

18

of the original would be a fake or art. And that's not our point. To grab that—an aesthetic education. 'To grab' > 'to grip' = *greifen* > *Begriff* = concept. I've played this out in and through W. B. Yeats in 'Situating Feminism'.[19] For the general argument about feminism, it is not without interest that the metaphor in 'concept' is shared with the motor of reproductive heteronormativity.

I am not suggesting that there is any kind of located meaning to an inscribed collectivity as the movement of differantiation takes place. That, too, is a hard lesson to learn. On the other side is the convenience of facts. Alice and I have resolutely kept to rumours, with the same boring 'authenticity' as all poorly edited oral history. Selected facts confound the ordinary with the resistant, thus fashioning identitarianism, culturalism. Our sources do not comment on the inscriptions but, rather, on the built space. The gutted warehouse is an architectural moment in the spectrum between spatial practice (here, inscription) and ruin (not allowed by developers), as the disappearing movement takes place, the differantiating moment as the present becomes past, indefinitely.

........

19 Gayatri Chakravorty Spivak, 'Situating Feminism' (lecture, Center for Race and Gender, University of Berkley, CA, 26 February 2010).

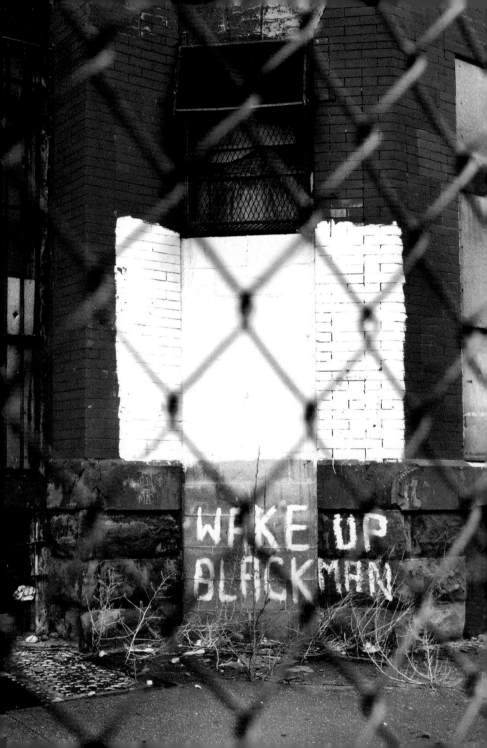

Let us create a pattern. Here is 'Wake k people', on an old Harlem storefront, which grandly and inadvertently provides an allegory of reading 'MOVING' (figure 5). Discontinuous inscriptions, the old economy a space for inscribing, both under erasure, both gone, united in Harlem's current seamless culturalism. You can tell the lost word is 'Black' simply by that *k*, 'up' is assumed, 'male female, young old', once tied to my allegory of reading,

Figure 4 (*facing page*) *Wake Up, Black Man,* Alice Attie (2000).[20]

Figure 5 (*pages 24–5*) *Male/Female,* Alice Attie (2000).

..

20 In these two photographs by Aniruddha Das, we see the new building on the site and what the black man has awakened to; with the rupture we can analogize with that between the work of the dream and waking life.

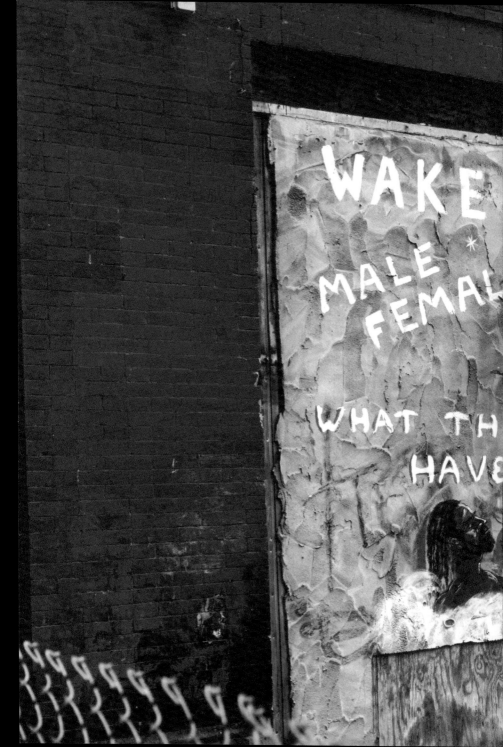

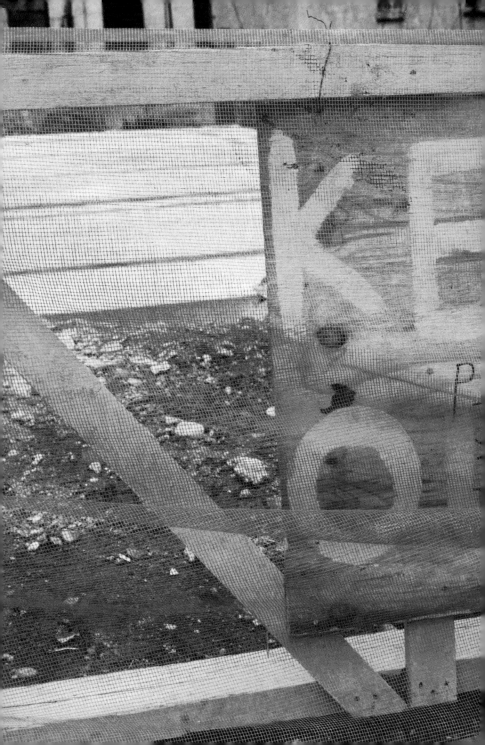

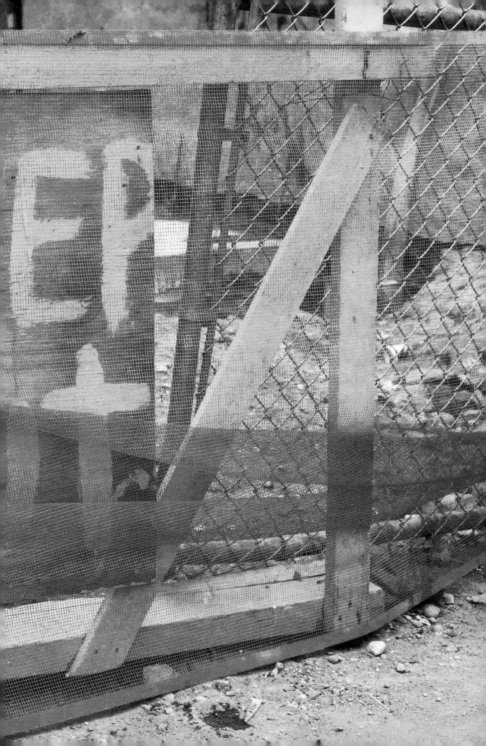

RECO

NO
- SITTING
- STANDING
- LOITERING

Thank You

Canaan Baptist Church

Pastor

130 W. 116ᵗʰ St:
PROPRIETE PRIVEE

INTERDIT DE MANGER ICI

INTERDIT DE S'ASSOIRE ICI

INTERDIT DE JETER DES
ORDURES ICI

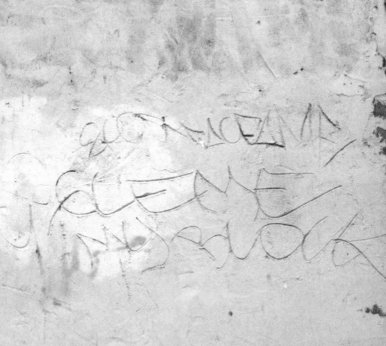

is, at the time of photography, anchorless. Indeed, what Harlem has and others use is now covered over. The object is not just lost by the covering over. It is the lost object in the future of the new Harlem.

Let us read figure 6 as an effective allegory of the anonymity. No one is sure as to who has asked whom to keep out of this lot. Here, there is no built space yet to distract the inhabitants' attention. The inscription commands reading yet is meaningless. It is now gone. The small rubble-strewn empty lot surrounded by barbed wire has been flattened. No one knows what will come up there. We could know if we made it a new 'political science' (I am on the editorial board of a journal of that name) research project, with predictable results. I am keeping the convenient conclusions at bay, they can have the predictable pluses and minuses depending on the investigators, but the inhabitants are not there. (I had thought about checking at time of revising but Alice had the right idea. She had not noted the location, just made this note: 'This was the only "Keep Out" sign that I came across in my year of photography throughout Harlem.')[21]

Figure 6 (*pages 26–7*) *Keep Out,* Alice Attie (2000).
Figure 7 (*pages 28–9*) *Records,* Alice Attie (2000).

..

21 Unpublished communication..

Records (figure 7) is a storefront on 116th Street that has been filled with concrete. The current inhabitants of the tenement above are relative newcomers, Haitians, who are suspended between the history of the store and the imminent future. The small notice is in French because it acknowledges this floating present. For the English speaker, a more austere notice: 'NO/sitting/standing/ loitering. Thank you. Owner.' The amiable Haitians, in suit and tie of a Wednesday evening, may have put this up. I didn't ask. One thing is sure. The only name scribbled on the soft concrete—'Allen'—is not the signatory of the message and not because of the absent patronymic. The archaeologist would undo the implausible text: Owner Allen.

An allegory again? I am a reader of words, not a drawer of foregone conclusions from images read as if evidentiary. Therefore inscriptions.

I place *Poem for Buster RIP* (figure 8) next. This is a memorial on which Kelley comments movingly.[22] Here a felicitous public space of mourning/ inscription is moving into the anonymous public space that memorializes the differantiating present as it disappears. Neither Kelley nor I will know 'Buster'. This is in excess of the general

..

22 Kelley, 'Disappearing Acts', p. 14.

SHOULD OF BEEN IN HIS PLACE.

WHO SAYS THE BAD ALWAYS DIE. WHO EVER
STATED THAT RUMOR, THEY WERE TALKING LIES.

LET ME TELL YOU ABOUT MY MAN, IF NOBODY
CAN DO IT, BUSTER CAN.

HE MADE A [...] PEOPLE
BY CHANGING HIMSELF [...] YOU KNOW LIKE

I KNOW, BUSTER [...] THE [...]

HE MADE THINGS [...] PEOPLE [...] NOBODY EVER
WILL FORGET. EVEN THE PEOPLE [...] KNOW IT

THEY WAS DOWN AND OUT, THEY STILL COULD GET MY
MAN, WAS A STRONG MAN, YOU COULDN'T KEEP HIM DOWN.

THE KINDNESS IN HIS HEART, WAS KNOWN FROM TOWN
TO TOWN.

I CAN KEEP THIS POEM GOING FOR DAYS, WITH PLENTY

THINGS TO SAY. BUT YOU WILL BE IN MY HEART AND STAY
IN MIND, EVERY SINGLE DAY. "FROM 125 AND 124" IN

"LENOX AVE" YOUR BODY WILL BE GONE BUT, THE
AVE. WILL ALWAYS MISS YOU.

structure without structure where all mourning, seeking to establish traffic with a transcendental intuition, is definitively unmoored. There is no guarantee that Buster is still at 1972 7th Avenue. We have not looked for him.

An article such as this one can have no ending. We are commenting on culture on the run, the vanishing present. But there is a closure for the historical record, the 'residual' restraint that I mentioned in my opening. *The Lenox Lounge* (figure 9) will remain. A different urban text will sediment meaning as it lexicalizes the lounge into the historical record. The insistent culturalism of *Harlem Song* at the Apollo Theater and the various television programmes is the ideological face of that lexicalization. It will appropriate the Harlem Renaissance and the New Negro.[23] Indeed, it can appropriate the theme of loss in a golden nostalgia. In a show at the Museum of the City of New York, there are some images devoted to

Figure 8 (*facing page*) *Poem for Buster RIP,* Alice Attie (2000).

...

23 George C. Wolf, *Harlem Song*, directed by George C. Wolf, Apollo Theatre, New York, NY, 8 July–29 December 2002. Alain Locke, *The New Negro* (New York: Atheneum, 1970). Of the many television programmes, the most exemplary is 'A Walk through Harlem: With David Hartman and Historian Barry Lewis' (PBS television), December 1999. Its slim accompanying

Harlem—and they belong to that genre.[24] That, too, is how architecture inhabits the spectrum between spatial practice and ruins. By scholarly hindsight, a collectivity will be assumed or assigned to have intended this bit of built space. That will be a structural truth claim. The anonymous, provisional, ghostly collectivities inscribed in and by these photographs, the edge of changeful culture caught on camera, will be delexicalized. This is an aporia of history, forever monumentalizing the stutter in the classic identity claim 'I am (not) one of us.' Memory has a 'posterior anteriority'—an 'I was there' before the fact—to which the historically established so-called cultural memory can only aspire.[25] 'Living' memory sustains us because it privatizes verifiability, effectively cancelling

..

volume, Andrew S. Dolkart and Gretchen S. Sorin (eds), *Touring Historic Harlem: Four Walks in Northern Manhattan* (New York, NY: Landmarks Conservancy, 1997), is a superb example of scholarly lexicalization into a seamless history, a continuous geography.

24 *Harlem Lost and Found*, curated by Michael Henry Adams, Museum of the City of New York, 3 May 2003–4 January 2004.

25 Emmanuel Levinas, *Totality and Infinity: An Essay on Exteriority* (Alphonso Lingis trans.) (Pittsburgh, PA: Duquesne University Press, 1969), pp. 169–70.

the question. The incessant production of cultural memory aspires to the public sphere by a species of 'subreption', the word Immanuel Kant uses to designate the attribution to nature of a sublimity that actually belongs to our 'respect for our own determination'.[26] It is a word that, in ecclesiastical law, means the 'suppression of truth to obtain indulgence'. By using this word for the built-in or constitutive character of the production of cultural memory, I draw a structural parallel with Kant's use of the word and have no intention to tie it to Kant's argument about nature and the moral will. The problem, at any rate, is not so much truth and falsity as public verifiability of culture by history.

To situate the lexicalization of the Lenox Lounge, I recall once again that moment in Du Bois's *Souls of Black Folk*—the outsider's hospitable entrance into Afro-Am.

Figure 9 (*pages 36–7*) *The Lenox Lounge,* Alice Attie (2000).

..

26 Immanuel Kant, *The Critique of Judgment* (J. H. Bernard trans.) (New York, NY: Hafner Press, 1951), p. 141. See also Gayatri Chakravorty Spivak, *A Critique of Postcolonial Reason: Towards a History of the Vanishing Present* (Cambridge, MA: Harvard University Press, 1999), p. 11n18.

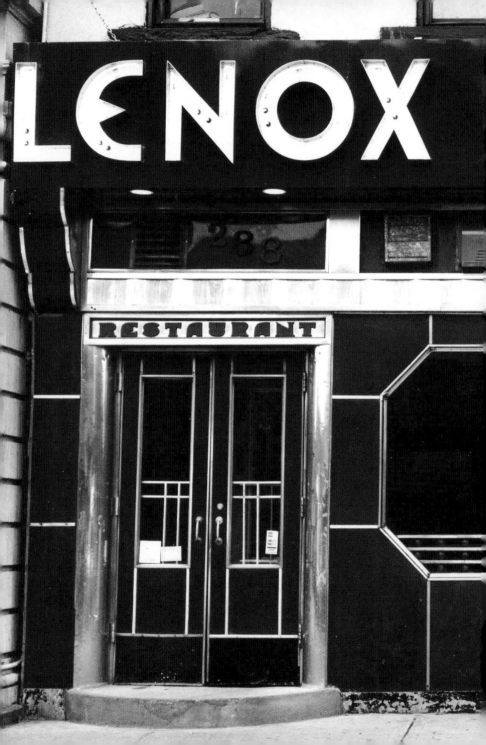

Souls of Black Folk is the prototype of the best vision of metropolitan cultural studies. At the head of each chapter, Du Bois takes a line of an African Spiritual and writes it in European musical notation. There we note the move to convert the performative into performance—an active cultural idiom lexicalized into the encyclopaedia or the museum—that is at the core of it. This is how the Lenox Lounge will enter the historical record—in a New World notation.

The Du Bois of the last phase moved to a different place. Disaffected with the US, the Pan-African Du Bois became a citizen of Ghana in Africa. We situate the traces of the other, ghostlier demarcations of collectivity caught in Attie's photos with the obstinate remnants of Du Bois's cherished *Encyclopaedia Africana*, emerging from anonymity in contemporary Ghana, as the official encyclopaedia of Africa thrives. What we offer here is related to that refusal to disappear. Du Bois's call for a state where 'the crankiest, humblest and poorest . . . people are the . . . key to consent of the governed,' seeking to redress Marx's regret at the end of 'The Eighteenth Brumaire of Louis Bonaparte' (1852), that the lumpenproletariat could not 'represent themselves', is now being claimed by the moral entrepreneurs of the international civil society

who would represent the world's minorities without a democratic mandate.[27]

What is it for Du Bois, the African-American who made that hyphenation possible, to become American-African? Hong Kong, British until day before yesterday, asks this question in terms of Asia and the US, as Asian American intellectuals come back after repatriation. For Dublin, Irish America is the next parish, whereas Little

..

[27] W. E. B. Du Bois, *Darkwater: Voices from within the Veil* in ODB, VOL. 19, p. 73. On the role of the international civil society in today's world, I have a serious difference with my long-term ally and dear friend Homi K. Bhabha. I hope to discuss this with him in the near future. The passage from Du Bois is cited in Homi K. Bhabha, 'Democracy De-realized' in Okwui Enwezor, Stefano Boeri, Ute Meta Bauer, Susanne Ghez, Mark Nash, Sarat Maharaj and Ocatavio Zaya (eds), *Democracy Unrealized: Documenta 11-Platform 1* (Ostfildern-Ruit: Hatje Cantz, 2002), p. 360. The full passage from Du Bois is: '[I]n future democracies the toleration and encouragement of minorities and the willingness to consider as "men" the crankiest, humblest and poorest and blackest peoples, must be the real key to the consent of the governed' (ODB, p. 73). The ellipses should be noticed. Du Bois's piece is indeed about 'the old cry of privilege, the old assumption that there are those in the world who know better what is best for others than those others know themselves, and who can be trusted to do their best. . . . They say of persons and classes: "They do not need the ballot"' (ODB, p. 68). My point is that self-selected moral

Bosnia is elsewhere.[28] These are movements in different directions. We must place Harlem in this world if we want to claim a supplement to globalism.

What are the remains of the event as *différance*? What is the responsibility of the memorializing collectivity? What mark will the old imprecise ghostly 'singularity'—the scattered 'Harlem' of these inscriptions—leave on film as the historical archives define it for scholarly use in a present that will cut itself off from it? A handful of photographs, deducing a collectivity from the ghost's track. These questions lead to different conclusions if you remember that politics is gendered.

The inscribed collectivities in the photographs are hardly ever women, and of course, never queer. This can be read in many ways. I have argued in another context

..

entrepreneurs fit this description. I will not comment here on the folly of drawing in the Levinas of *Otherwise Than Being* (1978) to endorse that role. Du Bois's use of the feminine metaphor in the subtitle of his book also bears further inquiry.

28 See, for instance, Kieran Allen, 'Immigration and the Celtic Tiger' in Gareth Dale and Mike Cole (eds), *The European Union and Migrant Labour* (New York: Berg, 1999), pp. 91–111; and Khalid Koser and Melisa Salazar, 'Ireland' in Steffen Angenendt (ed.), *Asylum and Migration Policies in the European Union* (Berlin: DGAP, 1999), pp. 217–27. I thank Benjamin Conisbee Baer for inspired research assistance.

that specific women's access to activism, not necessarily feminist activism, is socially produced in ways rather different from the male mainstream. I will not reproduce that argument here. I will repeat that, especially in the case of developmental activism, collectivity is constantly subsumed under the prevailing religion of individualism and competition, and this is true even of women. The activist may speak of collectivities, even work for groups of people, but it is the individuals who enter History. Thus *New York Times* and the well-known liberal Left journal *Nation* have picked up the cases of Dorothy Vaughan, whose old Harlem reconstruction project is going to be taken over by the gourmet supermarket Citarella, and Una Mulzac, who founded Liberation Bookstore in 1967 (figure 10) and was threatened with eviction in 2000.[29]

..

29 Nina Siegal, 'A Legendary Bookstore Gets a Last-Minute Lease on Life', *New York Times*, 30 July 2000. Available at http://www.nytimes.com/2000/07/30/nyregion/neighborhood-report-harlem-legendary-bookstore-gets-last-minute-lease-life.html (last accessed 3 September 2012). See also Kathleen McGowan, 'Fish Store Buys Bakery, Harlemites Say Deal Stinks', *City Limits Weekly*, 22 May 2000. Available at http://www.citylimits.org/news/articles/271/fish-store-buys-bakery-harlemites-say-deal-stinks (last accessed on 3 September 2012). The bookstore has since closed because of Mulzac's advancing age and consequent frailty.

They may not be immediately lexicalizable, like the Lenox Lounge, for which we go to Toni Morrison, Hortense Spillers, bell hooks, Queen Latifah, Maya Angelou. But they are, as it were, convertible to the format of the lexicon. We do not have their photographs because they do not belong to the anonymous unclaimable delexicalized collectivities. We are not privileging delexicalization or anonymity; we are memorializing the moment before obliteration. It is in that caution that I now turn to a couple of images of 'representative' Harlem women, unconnected to the inscriptions of collectivities (figures 11 and 12).

The lesson that I have learned over the last decades is that, unless there is infinite patience, not just in one of us but in all of us, to learn from below, we cannot stand for their collectivity, if anyone ever can, when freedom from oppression, from not having rights, turns round, one hopes, to the freedom to be responsible. It is always Nelson Mandela on the Springboks that one quotes: 'We have to surprise them with restraint and generosity.'[30]

Figure 10 (*facing page*) *Liberation Bookstore,* Alice Attie (2000).

..

30 Thomas L. Friedman, 'Surprise, Surprise, Surprise', *New York Times*, 21 August 2010. Available at http://www.nytimes.com/2010/08/22/opinion/22friedman.html?_r=1&scp=1&sq=Thomas+Friedman+Mandela&st=nyt (last accessed on 3 September 2012).

Thus, to that impossible 'if only . . .' I add the statement from Assia Djebar that I often cite: 'If only one could cathect [*investir*] that single spectator body that remains, encircle it more and more tightly in order to forget the defeat!'[31] This is where developing the possibility of 'being silent together', perhaps, becomes our task. This task is unverifiable and the desire to claim it on the part of the one above who wants to be downwardly mobile is strong. Because 'woman' remains a special case, there are human figures here—as if in a rebus. Their distance from the inscription of collectivities is part of a 'thing-presentation' rather than a 'word-presentation', to analogize somewhat irresponsibly from Freud to signify a position behind access to collective verbality.[32]

Here now are prosthetic inscriptions of female collectivity: buttocks, shoes, hats, heads (figures 13–16).

Figure 11 (*facing page*) *Fish and Chips,* Alice Attie (2000).
Figure 12 (*pages 46–7*) *Real Estate,* Alice Attie (2000).

...

31 Assia Djebar, 'Forbidden Gaze, Severed Sound' in *Women of Algiers in their Apartment* (Marjolijn de Jager trans.) (Charlottleville, VA: University of Virginia Press, 1992), p. 141.

32 Jean Laplanche and J.-B. Pontalis, *The Language of Psychoanalysis* (Donald Nicholson-Smith trans.) (New York, NY: W. W. Norton, 1973), p. 447–9, provides a list of the documentation to consult.

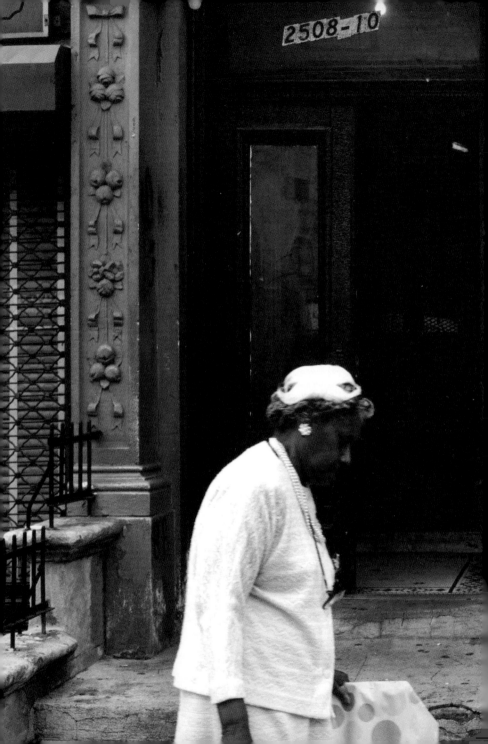

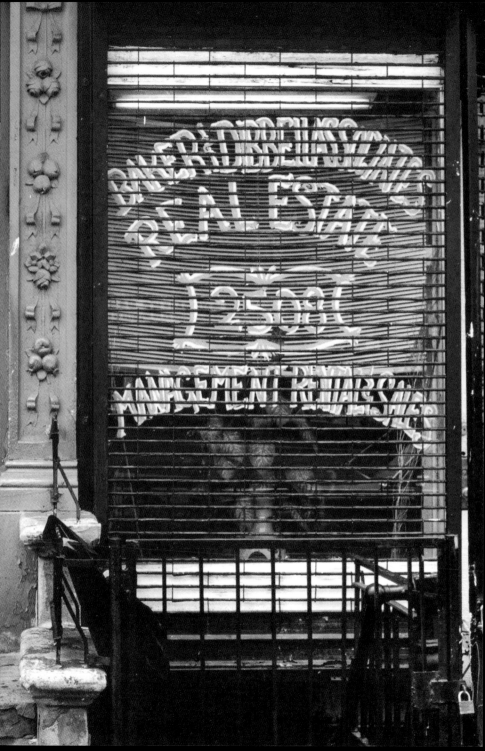

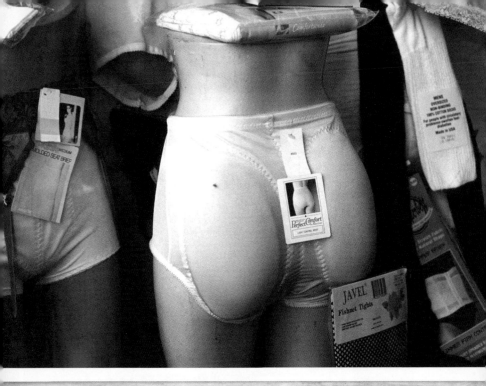

COCO*SHOES TEL: 864-1001

There was a gap in the window of Coco Shoes and in Virgo Beauty Salon Restaurant through which one could glimpse the inside. Today, this kind of combination and merger has been institutionalized on another level of capital abstraction. But here there is no attempt at coherence. To the outsider today, the storefronts mark a doubling that seems humorous, naive, perhaps witty. Was it always thus?

Figure 13 (*facing page, top*) *Perfect Comfort*, Alice Attie (2000).
Figure 14 (*facing page, bottom*) *Coco Shoes*, Alice Attie (2000).
Figure 15 (*below*) *Hats*, Alice Attie (2000).

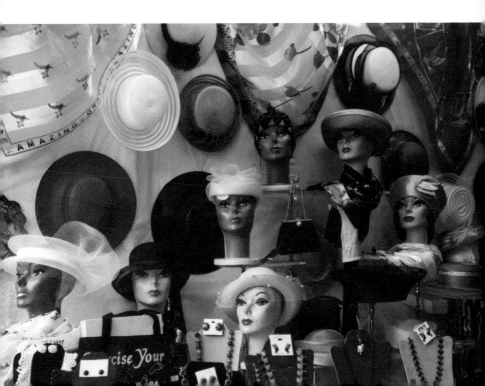

RESTAURANT

VIRGO
BEAUTY SALON

WE SPECIALIZE IN HAIR COLORING BLOW DRY
PERMANENTS MANICURE PEDICURE RELAXER

2304 283-9341

Now Corvette, one of the original large businesses in Harlem (figure 17). Driving down 125th Street towards the Triboro Bridge, Alice saw this blazing storefront as she was growing up. At the time of picture taking, there were rumours, what would come in its place? HMV, Old Navy, Modell's, Starbucks, Sony? Corvette is gone now and in its place is Duane Reade.

Here is one of Attie's shots of the future, this one a palimpsest of old Harlem revamped ('THE UNITED CHURCH OF PRAYER FOR ALL PEOPLE') and held reversed in the new globo-America (figure 18). The power to displace the new lexicalization, perhaps? But I am not speaking of individuals. I am talking about the disappearance of disenfranchised or disabled collectivities as we develop. I am talking about everyday social Darwinism, not only the survival of the fittest but also, if one thinks of the patter of the developers, 'the burden of the fittest'. Remember the innocence of the bearers of 'Ethernet'? Through an indoctrination into a relentless culturalism in the dominant, these kids will get the charge of the New Empire, not the bereft instrumentality of the high-tech Hong Kongers.

Figure 16 (*facing page*) *Virgo Beauty Salon,* Alice Attie (2000).
Figure 17 (*pages 52–3*) *Corvette,* Alice Attie (2000).

As it was, this picture took its domestic place with the international critique of my interlocutor in the subway station (figure 19). 'I had a dream, it is for you to fulfil it,' Martin Luther King Jr weeping. Now, the tears painted over, the mural shines with fresh colour between a new Lane Bryant and the old 'Kiss'. A bit of a Lenox Lounge here, although not quite so royal. (I revise on the 2010 anniversary of King's speech, and the conervative tele-journalist Glenn Beck has reclaimed King for racism.)[33]

In 1939–41, 'a few dozen [anonymous male] photographers fanned out to every corner of every borough [of metropolitan New York] to shoot virtually every building then standing.' The purpose here is not to memorialize but to construct a database for tax purposes. I have seen 14 of these. 'If only I could cathect that single spectator body that remains, encircle it more and more tightly in order to forget the defeat!'[34] (Figure 20).

Figure 18 (*facing page*) *United House—Disney,* Alice Attie (2000).
..

33 See C-Span, 'Restoring Honor Rally'. Available at http://-www.c-spanvideo.org/program/HonorRall (last accessed on 3 September 2012).

34 Jim Rasenberger, 'City Lore: A Lost City, Frozen in Time', *New York Times*, 30 July 2000. Available at http://www.-nytimes.com/2000/07/30/nyregion/city-lore-a-lost-city-frozen-in-time.html (last accessed on 3 September 2012).

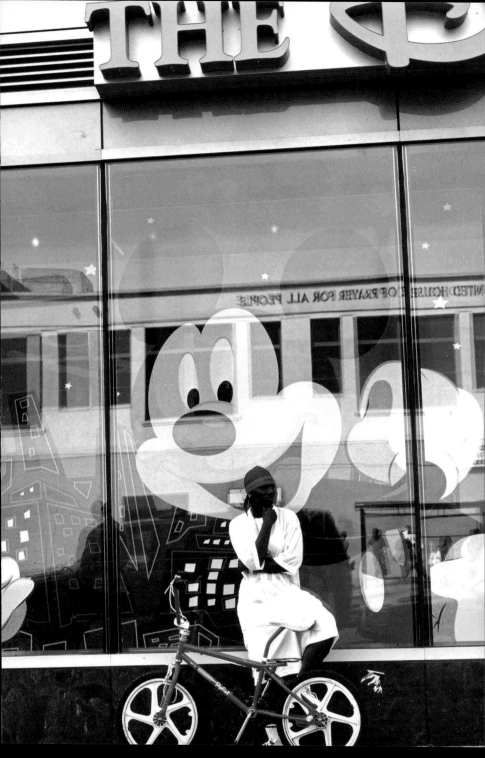

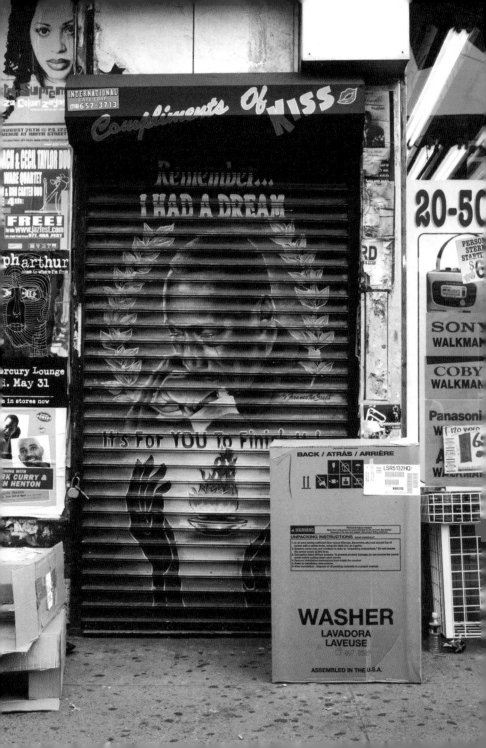

Figure 19 (*facing page*) *I Had a Dream,* Alice Attie (2000).

Figure 20 (*above*) *A Lost City, Frozen in Time* (1940). Tax Photographic Collection, Municipal Archives of the City of New York.

Could those anonymous male photographers have imagined a situation in New York City when, more than 60 years later, this wish would be expressed, by way of an Algerian and a half-Syrian sister, by a female East Indian New Yorker? That is the force of the 'perhaps', the undecidability of the future on which we stake our

political planning. Nothing may come of it. But nothing will survive without this effort. Love feeds research. It is a love that can claim nothing.[35]

Was there a failure of love in that silent independent short film of Orchard Street in the Lower East Side of New York City, made by Ken Jacobs in 1956, nine years before Lyndon Johnson relaxed the quota system in US immigration law? Because I am somewhat critical of the film, I felt hesitant about asking Jacobs to let me include clips, although I believe that he is no more caught in his time than we are in ours. White male independent filmmakers like him were attempting to distinguish themselves from Hollywood. Before the age of political correctness, the film betrays certain stereotypes, which

..

35 I have recently been reminded, by way of a publication request, that, translating Derrida, I had read the sentence 'this thought weighs nothing [*pèse rien*]'. Thought weighing nothing and love claiming nothing have a relationship. See Gayatri Chakravorty Spivak, 'Reading *De la grammatologie*' in Sean Gaston and Ian Maclachlan (eds), *Reading Derrida's 'Of Grammatology'* (New York, NY: Continuum, 2011), pp. xxix–xxxix. Conservative radicals will dismiss this as silly nihilism and my use of the catachresis 'love' as aestheticizing politics. Loss of allies is also a loss of hope. I will not seemingly change the conviction to get allies. Glenn Beck cannot be our role model.

give legitimacy to identity politics. The beautiful young East Asian woman, dressed in what could be sex-work clothes, sashays across the screen. The white child on a tricycle moves out of the screen at speed. A pair of African American legs in baggy trousers sweeps refuse up and down the screen, the only repeated shot in this short film. You wouldn't have guessed that Malcolm X was active in the city at this time. To be a New Yorker is also to keep the neighbourhoods separate.

I close with the permissible narrative of what disappears as development happens. 'What is an endangered species?' asked the wall text of Cynthia Mailman's exhibition in the Staten Island Institute of Arts and Sciences (figures 21 and 22). 'Simply put,' the text continued,

> [I]t is any organism whose population has declined to the point of possible extinction. During the past 400 years the human species has played an important role in the extinction of certain species. The most celebrated extinctions in recent times involve birds. The passenger pigeon, which once occurred in flocks numbering in the millions, the Carolina parakeet, great auk and Labrador duck all succumbed to the pressures of either overhunting or habitat

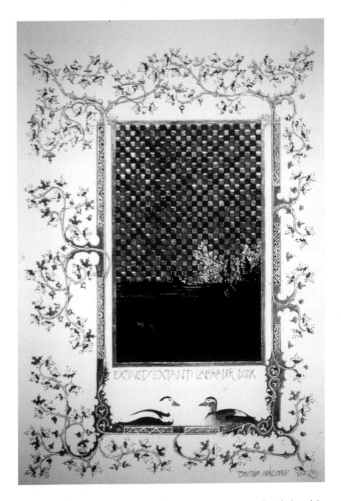

Figure 21 *Turn of the Century Wetlands, Staten Island*, Cynthia Mailman (1999). *Eco-Illuminations*, Staten Island Institute of Arts and Sciences, 2000.

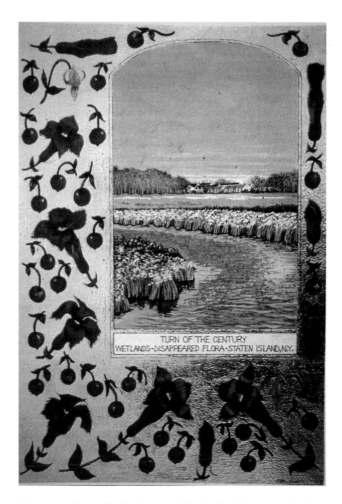

Figure 22 *Turn of the Century Wetlands, Disappeared Flora, Staten Island,* Cynthia Mailman (1998). *Eco-Illuminations,* Staten Island Institute of Arts and Sciences, 2000.

destruction, all within a relatively short period of time. [. . . W]e have to rely on the artist's renderings of the fringed gentian [warns the text], chokecherry and blue marsh violet since all have disappeared from the Staten Island landscape.[36]

The intent to memorialize can be signified by way of the frames, in the style of medieval illuminated manuscripts. And, because nature is presumed to be without history in this time frame, a species here can presumably come back as the same from the verge of extinction.

'This magnificent raptor,' runs the wall text for this one, 'was once on the verge of extinction due to thinning of its eggshells caused by pesticidal spraying. A ban on the use of DDT in the 1970s, coupled with Federal protection, paved the way for a successful comeback. In the 1990s it was removed from the endangered species list' (figure 23).

This romantic conviction ('no hungry generations tread thee down') is dubious at best. 'Biologically, the gene pool is badly impoverished; ecologically, its relation to the environment is radically altered. Are the herds of

..

36 Cynthia Mailman, *Eco-Illuminations: The Art of Cynthia Mailman*, Staten Island Institute of Arts and Sciences, New York, NY, 23 September–31 December 2000.

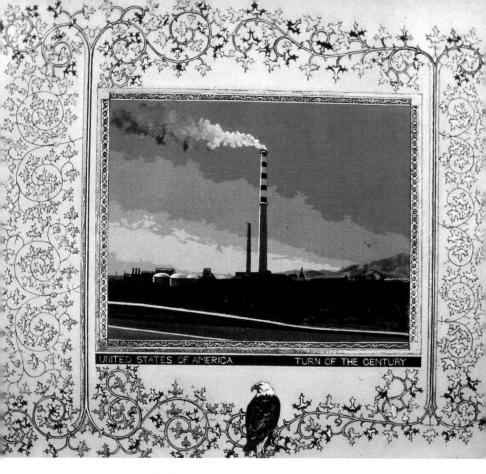

Figure 23 *United States of America, Turn of the Century,* Cynthia Mailman (1999). *Eco-Illuminations,* Staten Island Institute of Arts and Sciences, 2000.

bison raised in national parks "the same" as the herds the Indians hunted?'[37] But it is certain that there can be no hope of a successful comeback as a repetition of the same for inscribed collectivities, forever vanishing. A seamless

..

37 Henry Staten, unpublished communication.

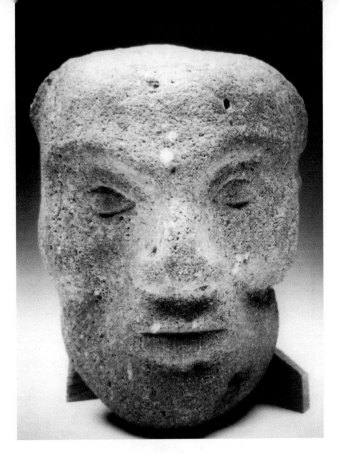

Figure 24 *'Lenape' Stone Head,* Bill Higgins (2000). Staten Island Institute of Arts and Sciences.

culturalism cannot be as effective as federal protection and a ban on DDT.

At the Staten Island institute, this head is part of the permanent collection (figure 24). The curator, Ed Johnson, writes as follows:

> The story of its finding is perhaps best told by George F. Kunz, who presented the head at a

meeting of the Natural Science Association of
Staten Island on 10 May 1884. . . . 'The features
are too well cut for a common off-hand piece of
work by a stonemaker: the style is not Egyptian
or Eastern; rendering it unlikely that it is a part
of an antiquity thrown away by some sailor; it is
rather Mexican, and still more resembles Aztec
work. This leads to the inference that it is possi-
bly of Indian origin . . .'[38]

Johnson also comments on the name 'Lenape' given
to the Indian head: 'A term derived from the Unami lan-
guage, meaning "common," "ordinary," or "real" people.
For convenience, used to describe the Indians who lived
on Staten Island and New Jersey in late prehistoric and
early historic times.'[39] It is indeed convenient to have one
serviceable name; as in the case of Yoruba, collectively
naming, for convenience, the delexicalized collectivities
of Òyó, Ègbá, Ègbádò, Ijèsà, Ijèbú, Ekítí, Nàgò into a
single colonial name.[40]

..

38 Printout given at the museum.

39 Ibid.

40 Henry John Drewal and John Mason (eds), *Beads, Body, and
Soul: Art and Light in the Yorùbá Universe* (Los Angeles, CA:
UCLA Fowler Museum of Cultural History, 1998), p. 278.

Where does originary hybridity begin? What, indeed, is it to be a New Yorker? We must push back on the trace of race in identity rather than insist on exclusive culture in order to ask that question. This is not to forget that the other side oppresses in the name of race but its opposite: not to legitimize it by reversal.

The naming of the Lenape loosens us from location, as does the convenience of Yoruba. Music mixes it up; jazz is hybrid at the origin.

The 'originary' is a move—like the clutch disengaging to get a stick-shift car moving. The originary is precisely not an origin. Thus the most recent arrival engages that originary move as well. Alice and I are caught in it. In the fierceness of divisive identitarianism and/or benign diversitarianism, how many such New Yorkers are we? What are the implications of corporate promotion of culture as tax shelter as in today's Harlem? New York is also the foremost financial centre in the US, perhaps in the world. Was there ever a felicitous sender and receiver of those inscriptions that Alice photographed?

Let it be marked here that I live now where the Lenape walked, to go down to the river to fish and catch clams and oyster—158th Street and Riverside Drive:

In April 1609, Henry Hudson sailed his ship the Half Moon up a river that would eventually bear his name, looking for passage to the Pacific. On the river's right bank stretched a verdant island some 13 miles long. The Native American Lenape people called it Manna-hatta, roughly translated as 'island of many hills.' Approximately two-thirds of the way up the island, in line with present-day 158th Street, Hudson and his crew passed a fishing camp, though in April, the Lenape people had probably not made their yearly migration to that spot yet. [. . .] Archeological evidence exposed during the construction boom of the early 1900s revealed that the Native American Lenape had once maintained a seasonal fishing camp at the foot of present-day 158th Street.[41]

..

41 Matthew Spady, *The Ground Beneath Our Feet*, Exhibition mounted on the occasion of the centenary of 'The Grinnell', New York, NY, 26 September 2010–12 December 2011. (The Grinnell is a nine-storey, triangular apartment building sitting at 800 Riverside Drive, on a plot bounded by Riverside Drive, Edward Morgan Place and 157th Street.) Figure 25 is derived from the same source.

The Lenape made maps in the head. Here is a paper map of their land. I live there now.

I live right next to what was once 'New Harlem': 'Within a quarter century of Hudson's 1609 voyage, Dutch colonists had settled in lower Manhattan and by 1637, a group had established a village in the flat expanse just south of the hills the Lenape people called Penadnic. The Dutch called their village New Harlem and the rocky heights to the north, Jochem Pieter's Hills.'[42]

It is the negotiability of senders and receivers that allows teleopoiesis, touching the distant other with imaginative effort. The question of negotiability, like all necessary impossibilities, must be forever begged, assumed as possible before proof. Space is caught in it, as is the calculus of the political, the economic and everything that writes our time. I ask you to negotiate between the rock of social history and the hard place of a seamless culture, to honour what we cannot ever grasp. Is there anyone out there any more for such negotiations, except in name?

Figure 25 (*facing page*) 'Washington Heights in Indian possession in 1600'.

..

42 Ibid.

I

Washington Heights
in
Indian possession
before 1600.

Showing the Weckquaesgeek
Path, and branch
trails, connecting
all known
village sites and
camping places.

BIBLIOGRAPHY

ABBAS, Ackbar. 'Hong Kong: Other Histories, Other Politics'. *Public Culture* 9 (1997): 293–313.

——. 'Hyphenation: The Spatial Dimensions of Hong Kong Culture' in Michael P. Steinberg (ed.), *Walter Benjamin and the Demands of History*. Ithaca, NY: Cornell University Press, 1996, pp. 214–31.

ALLEN, Kieran. 'Immigration and the Celtic Tiger' in Gareth Dale and Mike Cole (eds), *The European Union and Migrant Labour*. New York, NY: Berg, 1999, pp. 91–111.

ANDERSON, Jervis. *This Was Harlem: 1900-1950*. New York, NY: Noonday, 1981.

ATTIE, Alice. *Harlem on the Verge*. New York, NY: Quantuck Lane Press, 2003.

BHABHA, Homi K. 'Democracy De-realized' in Okwui Enwezor, Stefano Boeri, Ute Meta Bauer, Susanne Ghez, Mark Nash, Sarat Maharaj and Ocatavio Zaya (eds), *Democracy Unrealized: Documenta 11-Platform 1*. Ostfildern-Ruit: Hatje Cantz, 2002, pp. 346–64.

Cities without Citizens: Statelessness and Settlements in Early America. Curated by Aaron Levy. Rosenbach Museum and Library, Philadelphia, PA, 8 July–28 September 2003.

MAILMAN, Cynthia. *Eco-Illuminations: The Art of Cynthia Mailman*, Staten Island Institute of Arts and Sciences, New York, NY, 23 September–31 December 2000.

DERRIDA, Jacques. 'Declarations of Independence'. *New Political Science* 15 (1986): 7–15

———. 'Différance' in *Margins of Philosophy* (Alan Bass trans.). Chicago, IL: University of Chicago Press, 1982, pp. 3–27.

———. *Politics of Friendship* (George Collins trans.). New York, NY: Verso Books, 1997.

——— and Mustapha Tlili (eds). *For Nelson Mandela*. New York, NY: Seaver, 1987.

DJEBAR, Assia. 'Forbidden Gaze, Severed Sound' in *Women of Algiers in their Apartment* (Mrjolijn de Jager trans.). Charlotteville, VA: University of Virginia Press, 1992.

DOLKART, Andrew S. and Gretchen S. Sorin (eds). *Touring Historic Harlem: Four Walks in Northern Manhattan*. New York: Landmarks Conservancy, 1997.

DREWAL, Henry John and John Mason (eds), *Beads, Body, and Soul: Art and Light in the Yorùbá Universe*. Los Angeles, CA: UCLA Fowler Museum of Cultural History, 1998.

DU BOIS, W. E. B. *The Souls of Black Folk* in *The Oxford W. E. B. Du Bois* (Henry Louis Gates Jr ed.). New York: Oxford University Press, 2007.

FINNERTY, Amy. 'Outnumbered: Standing Out at Work'. *New York Times*, 16 July 2000. Available at http://partners.-

nytimes.com/library/magazine/home/20000716mag-work-mcdonald.html (last accessed on 3 September 2012).

FRIEDMAN, Thomas L. 'Surprise, Surprise, Surprise', *New York Times*, 21 August 2010. Available at http://www.nytimes.-com/2010/08/22/opinion/22friedman.html?_r=1&scp=1-&sq=Thomas+Friedman+Mandela&st=nyt (last accessed on 3 September 2012).

Harlem Lost and Found. Curated by Michael Henry Adams. Museum of the City of New York, 3 May 2003–4 January 2004.

LAPLANCHE, Jean and J.-B. Pontalis, *The Language of Psychoanalysis* (Donald Nicholson-Smith trans.). New York, NY: W. W. Norton, 1973.

JOHNSON, James Weldon. *Black Manhattan.* New York, NY: Da Capo Press, 1991.

KANT, Immanuel. *The Critique of Judgment* (J. H. Bernard trans.). New York, NY: Hafner Press, 1951.

KELLEY, Robin. 'Disappearing Acts: Capturing Harlem in Transition' in Alice Attie, *Harlem on the Verge.* New York: Quantuck Lane Books, 2003, pp. 9–17.

KOSER, Khalid and Melisa Salazar, 'Ireland' in Steffen Angenendt (ed.), *Asylum and Migration Policies in the European Union* (Berlin: DGAP, 1999), pp. 217–27.

LACAN, Jacques. 'The Mirror Stage' in *Ecrits* (Bruce Fink trans.). New York, NY: W. W. Norton, 2006, pp. 75–81.

LEVINAS, Emmanuel. *Otherwise Than Being: Or Beyond Essence* (Alphonso Lingis trans.). Dordrecht: Kulwer Academic Publishers, 1978.

——. *Totality and Infinity: An Essay on Exteriority* (Alphonso Lingis trans.). Pittsburgh, PA: Duquesne University Press, 1969.

Locke, Alain. *The New Negro*. New York, NY: Atheneum Books, 1970.

McGowan, Kathleen. 'Fish Store Buys Bakery, Harlemites Say Deal Stinks', *City Limits Weekly*, 22 May 2000 (Available at http://www.citylimits.org/news/articles/271/fish-store-buys-bakery-harlemites-say-deal-stinks (last accessed on 3 September 2012.)

Morris, Meaghan. 'On English as a Chinese Language: Implementing Globalization' in Brett De Bary (ed.), *Universities in Translation: The Mental Labour of Globalization*. Hong Kong: Hong Kong University Press, 2010, pp. 177–96.

Osofsky, Gilbert. *Harlem: The Making of a Ghetto*. Chicago, IL: Ivan R. Dee, 1996[1966].

Rasenberger, Jim. 'City Lore: A Lost City, Frozen in Time', *New York Times*, 30 July 2000. Available at: http://www.nytimes.com/2000/07/30/nyregion/city-lore-a-lost-city-frozen-in-time.html (last accessed on 3 September 2012).

Siegal, Nina. 'A Legendary Bookstore Gets a Last-Minute Lease on Life', *New York Times*, 30 July 2000. Available at http://www.nytimes.com/2000/07/30/nyregion/neighborhood-report-harlem-legendary-bookstore-gets-last-minute-lease-life.html (last accessed 3 September 2012).

Soja, Edward. *Postmetropolis: Critical Studies of Cities and Regions*. Malden, MA: Blackwell, 2000.

Spady, Matthew. *The Ground Beneath Our Feet*. Exhibition mounted on the occasion of the centenary of 'The

Grinnell', New York, NY, 26 September 2010–12 December 2011.

SPIVAK, Gayatri Chakravorty. 'Deconstruction and Cultural Studies: Arguments for a Deconstructive Cultural Studies' in Nicholas Royle (ed.), *Deconstructions: A User's Giude*. New York, NY: Palgrave, 2000, pp. 14–43.

——. 'Reading *De la grammatologie*' in Sean Gaston and Ian Maclachlan (eds), *Reading Derrida's 'Of Grammatology'*. New York, NY: Continuum, 2011, pp. xxix–xxxix.

——. 'Situating Feminism'. Lecture delivered at the Center for Race and Gender, University of Berkley, CA, 26 February 2010.

——. *A Critique of Postcolonial Reason: Towards a History of the Vanishing Present*. Cambridge, MA: Harvard University Press, 1999.

TSONG Pu. *Journey to the East 1997*. Hong Kong: Hong Kong University of Science and Technology Center for the Arts, 1997.

WOLF, George C. *Harlem Song*. Directed by George C. Wolf. Apollo Theatre, New York, NY, 8 July–29 December 2002.